ELEGY

WRITTEN IN

A COUNTRY CHURCH-YARD.

WITH VERSIONS IN THE

GREEK, LATIN, GERMAN, ITALIAN, AND FRENCH

LANGUAGES OF THE

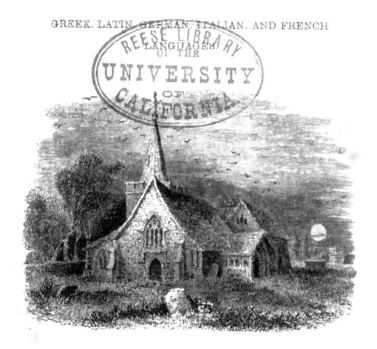

LONDON:

JOHN VAN VOORST, 1, PATERNOSTER ROW.

MDCCCXXXIX.

25089

LONDON :
PRINTED BY SAMUEL BENTLEY,
Bangor House, Shoe Lane.

TO

SAMUEL ROGERS, ESQ.

THIS

ILLUSTRATED EDITION

OF

G R A Y' S E L E G Y

IS DEDICATED

WITH THE GREATEST RESPECT,

THE great improvement that has taken place, within a few years, in the art of Engraving on Wood, as well as its general adoption, in some measure superseding the use of Copper and Steel, led to the present attempt to apply this mode of embellishment to a Poem of such general and deserved celebrity, and which appeared to afford the greatest scope for the talents of the artist.

The ELEGY itself has long been universally acknowledged as one of the most elegant compositions which the English language ever produced.

The following testimony to its great merit is not, perhaps, generally known, and will not here be inappropriately introduced.

General Wolfe received a copy on the eve of the assault on Quebec; he was so struck with its beauty, that he is said to have exclaimed, that he would have preferred being its author, to that of being the victor in the projected attack in which he so gloriously lost his life.

The favour with which this edition may be received, will be entirely owing to the talents of the eminent artists who have so kindly seconded the Editor, if he may apply such a word, in his wish to produce a specimen of beautiful and appropriate illustration in this branch of the Fine Arts ; and to them he begs to return his sincerest thanks.

<div align="right">JOHN MARTIN.</div>

London.
Oct. 10th, 1834.

A polyglott edition of this poem has been published, containing versions in the Greek, Latin, German, French, and Italian languages, accompanied with the English text.

THE favourable reception which this edition of one of the most popular poems in the English language has obtained, and the numerous translations which exist bearing ample testimony to its harmonious composition, has led to preparing this polyglott edition.

Perhaps few of the admirers of this elegant poem in its native tongue are aware of the homage paid to its eminent merits, by the attempts to render its beauties accessible to foreign readers : a list of these would occupy a considerable space, but those who are desirous of becoming acquainted with them, will find a very copious collection in the magnificent library of George III. in the British Museum ; it is, however, by no means complete.

Translations into Greek and Latin are the most numerous, principally by Etonians, with whom Gray stands so deservedly high. The difficulty in selecting the version in the former language has happily been removed, the refined taste of the author of " The Pur-

suits of Literature" having stamped the seal of his critical authority on that adopted.

"Gray glanced from high, and owned his rival Cooke."*

The Latin version is from the pen of the Rev. William Hildyard, who has most kindly permitted the editor to make use of it for this edition.

The German translation is printed from a collection of poetry in that language, entitled " Deutsches Lesebuch," Bremen, 1837, 8vo. the author of which subscribes himself Gotten.

The Italian version is by Guiseppe Torelli, and has been selected from several at the recommendation of a distinguished native of that country, deservedly considered the highest authority in Italian literature of the present day.

* This version is printed at the end of an edition of Aristotle on Poetry, edited by W. Cooke. 8vo. Cantab. 1785. The author alluded to states that, in many passages, " Nature, Gray, and Cooke, do seem to contend for the mastery, but, above all, in the famous stanza,

'The boast of heraldry,' &c.

Bion, or Moschus, never exceeded these lines: I think they never equalled them."

The French translation is by Le Tourneur, author also of a similar attempt with " Young's Night Thoughts" and " Hervey's Meditations ;" a language, it would appear, the least capable of any other of communicating a faithful idea of the original.

It had been wished to have added versions in the Spanish and Portuguese languages, which are said to exist ; but although diligent search has been made, it was without success.

It is impossible to conclude this slight notice of this poem without a feeling of exultation at the tribute paid by foreigners to the transcendant merits of a composition, which the highest critical authority in our own country has declared it would be idle to praise.

J. M.

Woburn Abbey,
25 March, 1839.

ILLUSTRATIONS.

STANZAS.	PAINTERS	ENGRAVERS.
1	G. Barret	E. Landells.
2	Copley Fielding	J. Byfield.
3	J. Constable, R.A.	T. Bagg.
4	G. Cattermole	J. Byfield.
5	J. Constable, R.A.	W. H. Powis.
6	T. Stothard, R.A.	C. Gray.
7	P. Dewint	T. Williams.
8	W. Boxall	Branston.
9	S. A. Hart, A.R.A.	J. Jackson.
10	G. Cattermole	J. Smith.
11	J. Constable, R.A.	T. Bagg.
12	Thomas Landseer	J. Byfield.
13	Frank Howard	T. Williams.
14	W. Westall, A.R.A.	S. Slader.
15	A. W. Callcott, R.A.	J. Thompson.
16	J. H. Nixon	J. Jackson.
17	A. Cooper, R.A.	S. Williams.
18	W. Mulready, R.A.	J. Thompson.
19	J. W. Wright	C. Gray.
20	Charles Landseer	S. Slader.

STANZAS	PAINTERS	ENGRAVERS
21	J J. CHALON, A. R. A	BRANSTON.
22	H. HOWARD, R A.	M. HART.
23	R. WESTALL, R. A.	C GRAY.
24	J. W. WRIGHT	C. GRAY.
25	COPLEY FIELDING	J. JACKSON.
26	G. BARRET	J. BAXTER.
27	THALES FIELDING	SLY AND WILSON
28	C. R. STANLEY	J. JACKSON.
29	W. COLLINS, R. A.	H. WHITE.
30	FRANK HOWARD	T. WILLIAMS
31	H. HOWARD, R. A.	C. GRAY.
32	S. A. HART, A R. A.	C. GRAY.

The vignette on the title-page, engraved by W. H. Powis, is a view of Stoke-Poges church, Buckinghamshire, the church-yard of which is the scene of this celebrated poem, and near which is a monument erected to the memory of Gray by the late John Penn, Esq. of Stoke Park. The drawing, by John·Constable, Esq. R. A. has been kindly offered to the editor since the publication of the former edition, and is in the possession of Samuel Rogers, Esq.

The tomb of the poet is at the south-east corner of the chancel, near that of his aunt, Mrs. Mary Antrobus.

I.

Νὺξ πέλει, οὐδ᾽ ἀν᾽ ἀγρὼς πυρὰ καίεται, οὐδ᾽ ἀνὰ κώμας·
Μυκηθμῷ λειμῶνα βόες βραδέως κάμπτοντι·
Οἴκαδ᾽ ἴατ᾽ ἀροτρεὺς ἀμπαύσων σῶμα κεκμακὸς,
Κάδ᾽ δ᾽ ἐμὲ δὴ μόνον εὖντα μελαίνα πέπταται ὄρφνα.

I.

AUDIN' ut occiduæ sonitum campana diei
 Reddit, et à pratis incipit ire pecus;
Jam proprios petit ipse Lares defessus arator,
 Et passim, extinctis ignibus, omne silet.

I.

Die Abendglocke ruft den müden Tag zu Grabe;
Mattblöckend, kehrt das Vieh in langsam schwerem Trabe
Heim von der Au; es sucht der Landmann seine Thür
Und überläßt die Welt der Dunkelheit und mir.

I.

Segna la squilla il dì, che già vien manco;
Mugghia l' armento, e via lento erra e sgombra;
Torna a casa il bifolco inchino e stanco,
Et a me lascia il mondo e a la fosc' ombra.

I.

LE jour fuit; de l'airain les lugubres accens
Rappellent au bercail les troupeaux mugissans;
Le laboureur lassé regagne sa chaumière;

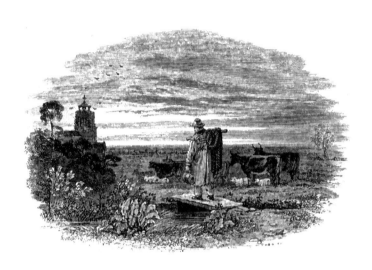

I.

THE Curfew tolls the knell of parting day;

 The lowing herd winds slowly o'er the lea;

The ploughman homeward plods his weary way,

 And leaves the world to darkness and to me.

II.

Ὠρεά τε σκιόωνται, ἰδ᾽ ἄλσεα μακρὰ καὶ ὕλαι,
Ηνίδε· θεσπεσία κατέχει πάντ᾽ αἰθέρα σιγὰ,
Αἰ μὴ ὅπα δινεῖ πτερὰ κάνθαρος, ἠΰτε κηφὴν,
Ηχεα καὶ βομβεῦντα κατ᾽ αὐλὰς ποίμνια θέλγει·

II.

Nunc crepera ex oculis rerum evanescit imago,
 Altaque per cælos regnat amica quies,
Nî rotet agrisonum sese scarabæus in orbem,
 Tinnitusque gravis pulset ovile procul.

II.

Der Landschaft zitternd Bild sinkt in der Dämm'rung Hülle,
Und durch die ganze Luft herrscht feierliche Stille;
Nur daß ein Käfer hier mit trägem Fluge schwirrt,
Und schläfrig um mein Ohr ein fernes Läuten irrt,

II.

Già fugge il piano al guardo, e gli s' invola,
E de l' aere un silenzio alto s' indonna,
Fuor 've lo scarabon ronzando vola,
E un cupo tintinnir gli ovili assonna;

II.

Du soleil expirant la tremblante lumière
Délaisse par degrés les monts silencieux;
Un calme solennel enveloppe les cieux,

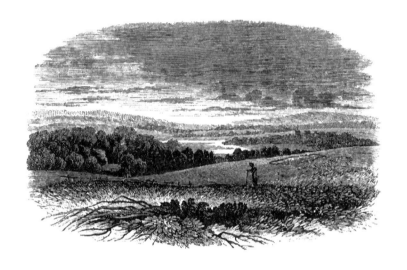

II.

Now fades the glimmering landscape on the sight,
 And all the air a solemn stillness holds,
Save where the beetle wheels his droning flight,
 And drowsy tinklings lull the distant folds :

III.

Αἰ μὴ ὄπα κισσῷ πεπυκαδμένον αἶπυ λιποῖσα
Γλαὺξ ἔδος ἀΰσεν, σέ τ᾽ ἐβώσατο, πότνα Σελάνα,
Ὀξυ μάλα στοναχεῦσ᾽, ὅτ᾽ ἀλώμενος ἦνθεν ὁδίτας,
Σινόμενος δόμον ἔνθ᾽, ὄπα ἐν ναοῖσιν ἐκρύφθη.

III.

Nì, quà, tecta hedeiâ, venit illic turris in auras,
 Noctua funestum fundat ab ore melos ;
Multa querens homines regni violare silentis
 Numina, dum tremulo lumine Luna micat.

III.

Und daß aus jenem Thurm', den Epheu dicht umschlinget,
In dessen alte Kluft kein Strahl des Tages dringet,
Die Eule schauervoll dem blassen Monde klagt,
Ein Wand'rer habe sie zu stören sich gewagt.

III.

E d' erma torre il gufo ognor pensoso
Si duole, al raggio de la luna amico,
Di chi, girando il suo ricetto ombroso,
Gli turba il regno solitario antico.

III.

Et sur un vieux donjon que le lierre environne,
Les sinistres oiseaux, par un cri monotone,
Grondent le voyageur dans sa route égaré,
Qui vient troubler l'empire à la nuit consacré.

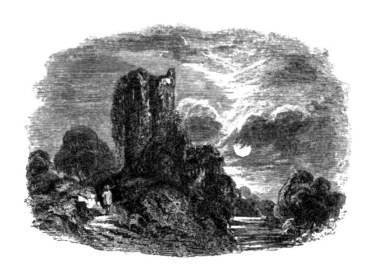

III.

Save that, from yonder ivy-mantled tower,

 The moping Owl does to the Moon complain

Of such as, wandering near her secret bower,

 Molest her ancient solitary reign.

IV.

Τήναις ταῖς πτελέῃσιν ὑπόσκιος, ἢ κυπαρίσσοις
Γαῖα ὅπα κέχυται, πυκινοί τ' ἀνὰ βώλακα τύμβοι,
Κείμενοι ἄλλοθεν ἄλλοι ἀτέρμονα νήγρετον ὕπνον
Εὕδονθ' οἱ Πρόγονοι κωματᾶν, ἄγρια φῦλα.

IV.

Ulmus ubi pandit ramos, ubi taxus opacum
　　Diffundit frigus, cespes et ossa tegit ;
“ Quisque suos patiens manes,” placidâque quiete,
　　Majores vici contumulantur humo.

IV.

Hier, wo die Ulme trau'rt, der Eibe Schatten schrecket,
Wo mürbe Hügel Staub's ein dürrer Rasen decket,
Schläft, in ein enges Grab versenkt auf immerdar,
Von diesem armen Dorf' der Väter rohe Schaar.

IV.

Di que' duri olmi a l' ombra, e di quel tasso,
'Ve s' alzan molte polverose glebe,
Dorme per sempre, in loco angusto e basso,
De la villa la rozza antica plebe.

IV.

Près de ces ifs noueux dont la verdure sombre
Sur les champs attristés répand le deuil et l'ombre,
Sous ces frêles gazons, parure du tombeau,
Dorment les villageois, ancêtres du hameau.

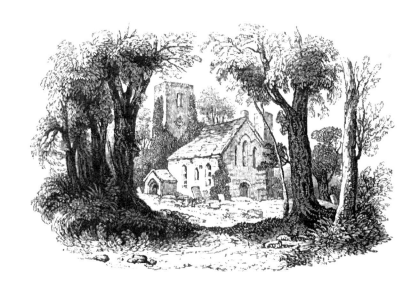

IV.

Beneath those rugged elms, that yew-tree's shade,

 Where heaves the turf in many a mouldering heap,

Each in his narrow cell for ever laid,

 The rude forefathers of the hamlet sleep.

v.

Τήνως οὐκ Ἀὼς θυόεσσά ποκ᾽, οὐδὲ χελιδων
Σεισαμένα πτερὰ πᾷ καλίας ἀπὸ καρφίταο,
Οὐδ᾽ ὄρνις κλαγγεῦσα ἐπ᾽ ἠώοισι πετεύροις,
Τὼς οὐδ᾽ εὐνᾶθεν κέρας ἀερόφωνον ἀνεγρεῖ.

v.

Heu! frustrà vinctos durâ sub compede mortis
 Auroræ allicient thuriferentis opes!
Frustrà eheu! galli cantus, cornuve sonorum,
 Stramineo aut vocitans tegmine hirundo casæ!

v.

Sie ruft der Morgen nun, der düftend niederwallet,
Der Schwalbe zwitschernd Lied, das aus dem Strohdach' schallet,
Des Hahn's Trompetenton, des Hornes Wiederklang
Nicht mehr vom schlechten Beet' zu Arbeit und Gesang.

v.

L' aura soave del nascente giorno,
Di rondine il garrir su rozzo tetto,
Del gallo il canto, o il rauco suon del corno
Più non li desterà da l' umil letto.

v.

Rien ne peut les troubler dans leur couche dernière,
Ni le clairon du coq annonçant la lumière,
Ni du cor matinal l'appel accoutumé,
Ni la voix du printemps au souffle parfumé.

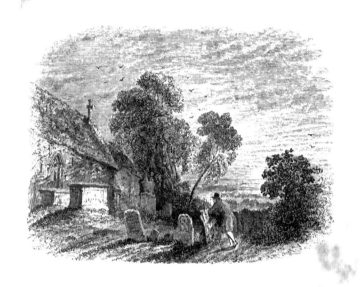

v.

The breezy call of incense-breathing Morn,

 The swallow twittering from the straw-built shed,

The cock's shrill clarion, or the echoing horn,

 No more shall rouse them from their lowly bed.

<div align="center">VI.</div>

Τήνοις οὐδ' ἔτι δὴ ξύλα θήσει ἐπ' ἐσχάρᾳ ἐνδοῖ
Πρέσβα γυνὰ, διὰ δῶμα ποθέσπερα ποιπνύσασα·
Οὐδ' ἔτι φὶν παῖδες περιπλέξονται γονάτεσσι,
Ἀλλήλοϊν ἐρίσδοντες πατρὸς ἀμφὶ φίλαμα.

<div align="center">VI.</div>

Illis haud iterum simplex domus igne nitebit,
 Qua properat vestes uxor amata viro ;*
Haud iterum adcurrent "dulces circum oscula nati,"
 Neu patris in gremio se glomerare petent.

<div align="center">VI.</div>

Nicht mehr wird nun für sie des Herdes Flamme lobern,
Kein Weib am Abend sie mit Sehnsucht wiederfobern,
Sich den Geschäften ganz für ihre Pflege weihn,
Und keine Kinder mehr nach ihrem Vater schrein,
Still lauschen, wenn er kommt, sich ihm entgegendrängen
Und, sich um einen Kuß beneidend, an ihn hängen.

<div align="center">VI.</div>

Per lor non più arde il foco, o attenta madre
A le sue cure vespertine attende :
La balba famigliuola in grembo al padre
Non repe e baci invidïati prende.

<div align="center">VI.</div>

Des enfans, réunis dans les bras de leur mère,
Ne partageront plus, sur les genoux d'un père,
Le baiser du retour, objet de leur désir ;
Et le soir au banquet la coupe du plaisir
N'ira plus à la ronde égayer la famille.

<div align="right">* THOMSON's *Winter*, line 311.</div>

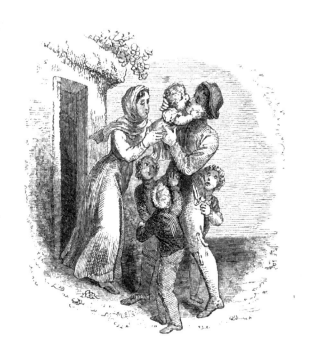

VI.

For them, no more the blazing hearth shall burn,

Or busy housewife ply her evening care ;

No children run to lisp their sire's return,

Or climb his knees, the envied kiss to share.

VII.

Τῶν ὑπὸ τᾷ δρεπάνα πέσε δράγματα πολλάκ' ἔρασδε,
Αὔλακα πολλάκι τοὶ κλασιβώλακι τέμνον ἀρότρῳ·
Ὡς ἱλαρῶς τὰς ἄμαξας, ἰδ' ἵππως ἆγον ἀγρόνδε,
Ὡς ὑπὸ τῶν πελέκεσσι κάμον πολυδένδρεες ὗλαι.

VII.

Sæpe expectatis flavescens messis aristis,
 Accisa illorum falce, tegebat humum ;
Ah ! quotiès læti urgebant jumenta per agros,
 Frangebant quoties pinguia terga soli !

VII.

Oft tönete die Flur von ihrer Sichel Klang' ;
Es war ihr Pflug, der oft die harten Schollen zwang.
Wie froh zog ihr Gespann vor ihnen auf die Felder !
Wie beugten sich, erlegt durch ihren Streich, die Wälder !

VII.

Spesso a la falce lor cesse il ricolto,
Spesso domàr le dure zolle i ferri.
Come lieti lor tiro al campo han vôlto !
Com' piegàr sotto a' gravi colpi i cerri !

VII.

Que de fois la moisson fatigua leur faucille !
Que de sillons traça leur soc laborieux !
Comme au sein des travaux leurs chants étaient joyeux,
Quand la forêt tombait sous les lourdes cognées !

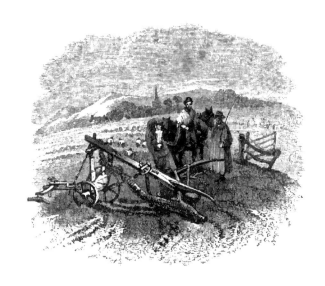

VII.

Oft did the harvest to their sickle yield ;

 Their furrow oft the stubborn glebe has broke ;

How jocund did they drive their team a-field !

 How bow'd the woods beneath their sturdy stroke !

VIII.

Μηδ᾽ ὔμμες κάτω ἕλκετ᾽, ἀλαζόνες, ὅσσ᾽ ἐπόνασαν
Οὐκ ἀνόνητα, κόπω μοῖραν καμάτω τε λαχόντες,
Μηδὲ γελᾷ σοβαρόν τι γ᾽ ὁ πλώσιος, αἴ ποκ᾽ ἀκούσῃ
Ανέρας ἀγρονόμως φαμά τις ἄφαμος ἀέξει.

VIII.

Parcite vos magni, cæcâ ambitione ruentes,
 Parcite vos humilem ludificare gregem !
Nec moveat tumidæ procerum fastidia menti
 Pagina, quæ sanctæ nomina plebis habet.

VIII.

Der Ehrgeiz spotte nicht der Arbeit ihrer Hand,
Verlache nicht ihr Glück und ihren niebern Stand;
Der Große höre nicht, Hohnlächeln im Gesichte,
Des armen kurze, doch belehrenbe Geschichte.

VIII.

Non beffi l' opre lor fasto superbo,
L' oscura sorte, i rustici diletti,
E non ascolti con sorriso acerbo
De' poverelli i brevi annali e schietti.

VIII.

Que leurs tombes du moins ne soient pas dédaignées ;
Que l'heureux fils du sort, déposant sa grandeur,
Des simples villageois respecte la candeur ;
Que ce sourire altier sur ses lèvres expire :

Let not Ambition mock their useful toil,

 Their homely joys, and destiny obscure;

Nor Grandeur hear, with a disdainful smile,

 The short and simple annals of the poor.

IX.

Α χάρις εὐγενέων, χάρις ἢ βασιληίδος ἀρχᾶς,
Δῶρα Τύχας, χρυσᾶς Ἀφροδίτας καλὰ τὰ δῶρα,
Πάνθ' ἅμα ταῦτα τέθνακε, καὶ ἦνθεν μόρσιμον ἆμαρ·
Ηρώων κλέ' ὄλωλε, καὶ ᾤχετο ξυνὸν ἐς Ἄδαν.

IX.

Stemmata quæ longo volvuntur in ordine, gazæ,
 Flosque juventutis, purpureusque nitor,
Omnia nox eadem manet — heù persæpe sepulchro
 Gloria funeream prætulit ipsa facem !

IX.

Nicht zu vermeiden droht ein letzter Augenblick
Dem Dünkel der Geburt, der Herrschaft stolzem Glück',
Der Schönheit Zaubermacht, des Geistes Eigenthume;
Zum Grabe leiten nur die Wege zu dem Ruhme.

IX.

Qual per sangue e real pompa s' onora,
Quanto mai l' or, quanto beltà dar possa,
L' istessa aspetta inevitabil ora.
Anco la via d' onor guida a la fossa.

IX.

Biens, dignités, crédit, beauté, valeur, empire,
Tout vient dans le lieu sombre abîmer son orgueil.
O gloire ! ton sentier ne conduit qu'au cercueil.

IX.

The boast of heraldry, the pomp of power,

 And all that beauty, all that wealth, e'er gave,

Await, alike, th' inevitable hour ;—

 The paths of glory lead but to the grave.

X.

Τήνοις οὐδ' ὕμμες, ὑπερήφανοι, ἅπτετ' ὀνείδη,
Αἰ μὴ πᾷ τὼν οὐδὲν ὑπὲρ κόνιν ἠρίον ἔστα,
Ενθ' ὅπα ἐν ναοῖσιν ὁμηγερέες βροτοὶ εὐχαῖς
Τὸν Θεὸν ἦ μολπαῖς τὸν ὑπέρτατον ἱλάσκονται.

X.

Nec culpæ adtribuant illis gens turgida fastû
 Quòd tituli bustis nulla trophæa ferant,
Ædes quà extentas inter, laqueataque tecta,
 Plurima consurgit laudis Hosanna Deo.

X.

Verzeihe denn, o Stolz, daß glänzende Trophä'n
Zu ihrer Ehre nicht um diese Gräber steh'n,
Und daß im Tempel nicht durch tiefgewölbte Hallen
Der Chöre Harmonie'n von ihren Thaten schallen.

X.

Nè tu sprezzar, o altier, cotesta tomba,
Se non orna trofeo l' ossa sepolte,
Nè bell' inno di lode alto rimbomba
Per lunghe logge e istoriate volte.

X.

Ils n'obtinrent jamais, sous les voûtes sacrées,
Des éloges menteurs, des larmes figurées ;
Les ministres du ciel ne leur vendirent pas
Le faste du néant, les hymnes du trépas :

X.

Nor you, ye proud! impute to these the fault,

 If Memory o'er their tomb no trophies raise;

Where, through the long-drawn aisle and fretted vault,

 The pealing anthem swells the note of praise.

XI.

Ἀρά γε δαιδαλέα σορὸς, ἠδ᾽ εὔξεστον ἄγαλμα
Ἐς φάος ἄνστησέν ποχ᾽ ὅτῳ λίπεν ὀστέα θυμὸς;
Ἀρά γέ τοι κωφὰ κόνις ἔκλυε δοῦπον Ἄρηος;
Ἀρά γε μειλιχίοισι παραῤῥητὸς πέλεν Ἅδης;

XI.

Urna incisa notis, aut " vivi ex marmore vultus,"
 Ætherios ignes an revocare valet?
Ah! quando è tacitâ surgent responsa favillâ?
 Audiet aut quando trux Libitina preces?

XI.

Ergötzt ein Marmorbild den nachtumwölkten Blick?
Lockt den entfloh'nen Geist ein Trauermahl zurück?
Kann in die öde Gruft des Ruhmes Nachhall dringen?
Läßt sich des Todes Ohr durch Schmeicheleien zwingen?

XI.

Puote forse opra di scarpello arguto
Richiamar l' alma a la sua spoglia ignuda?
O può canto eccitare il cener muto,
E allettar morte inesorabil, cruda?

XI.

Mais, perçant du tombeau l'éternelle retraite,
Des chants raniment-ils la poussière muette?
La flatterie impure, offrant de vains honneurs,
Fait-elle entendre aux morts ses accens suborneurs?

XI.

Can storied urn, or animated bust,

 Back to its mansion call the fleeting breath?

Can Honour's voice provoke the silent dust?

 Or Flattery soothe the dull cold ear of Death?

.

XII.

Ενθάδε πᾳ κεῖται στυγνῷ κ' ἐν ἀτερπέϊ χώρῳ
Τῷ πόκ' ἂν ὠρανίῳ ῥιπὰ πυρὸς ἦτορ ἀνῆψεν·
Καὶ χέρες, αἵ κε σκῆπτρα πάλαι φορέσειαν ἄμωμοι,
Εμψύχου τε λύρας μέλος ἔνθεον ἐκκρούσειαν.

XII.

Hosce inter tumulos forsan, secretaque regna,
 Cælesti olim aliquis præditus igne jacet ;
Dextra potens cujus sceptro fulsisset eburno,
 Aptâssetve modis carmina grata lyræ.

XII.

Wie manche deckt vielleicht hier die Verwesung tief,
In deren stiller Brust ein Götterfunke schlief!
Provinzen hätten sie mit wachem Blick' beschirmet,
In hohes Saitenspiel Begeisterung gestürmet,

XII.

Forse in questo negletto angolo alberga
Spirto già pieno d' un ardor celeste ;
O man degna che tratti real verga,
E vocal cetra a nobil canto deste.

XII.

Des esprits enflammés d'un céleste délire,
Des mains dignes du sceptre, ou dignes de la lyre,
Languissent dans ce lieu par la mort habité.

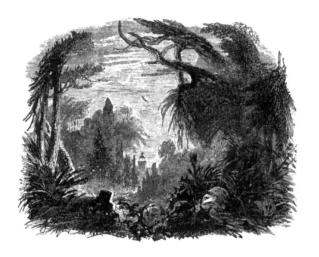

XII.

Perhaps, in this neglected spot, is laid

 Some heart, once pregnant with celestial fire;

Hands, that the rod of empire might have sway'd,

 Or wak'd to ecstasy the living lyre.

XIII.

Οὐ γὰρ ἀνέπτυξεν τήνων εἰς ὄμματα μακρὰς
Α Σοφία σελίδας, τὰ κρόνω ταὶ σκῦλα φορεῦντι·
Τήνοις ἁ Πενία κατέρυξεν ἐλεύθερον ὁρμὰν,
Τήνων καὶ ψυχᾶς ἤμβλυν’ εὐάνθεμον ἀκμάν.

XIII.

Ast oculis nunquàm monimenta Scientia, plena
 Annorum exuviis, conspicienda dedit ;
Res dura, et miseris urgens in rebus egestas,
 Mentibus imposuit væ! glaciale gelu!

XIII.

Hätt’ ihnen Wissenschaft ihr großes Buch entrollt,
In welches jede Zeit den Schatz der Völker zollt ;
Hätt’ Elend nicht ihr Haupt in tiefen Staub gedrücket,
Ihr Feuer ausgelöscht und ihr Genie ersticket.

XIII.

Ma lor Sofía non svolse il gran volume,
Che ’l tempo di sue spoglie ornò e distinse
Tarpò al bell’ estro povertà le piume,
E ’l corso a l’ alme con suo gelo strinse.

XIII.

Grands hommes inconnus, la froide pauvreté
Dans vos âmes glaça le torrent du génie ;
Des dépouilles du temps la science enrichie
A vos yeux étonnés ne déroula jamais
Le livre où la nature imprima ses secrets ;

XIII.

But Knowledge, to their eyes, her ample page,

 Rich with the spoils of time, did ne'er unroll;

Chill Penury repress'd their noble rage,

 And froze the genial current of the soul.

XIV.

Ἦ ῥά νυ μάργαρα πόλλ' ἁλίοις ἐνὶ βένθεσι κεῖται,
Καὶ κρύφιον σέλας αἰὲς ἐτώσιον ἀστράπτοντι·
Πολλά τ' ἄοπτά τ' ἄιστά τ' ἐν εἴαρι γίνεται ἄνθη,
Τῶν γάνος εὔοδμον κατετάκετ' ἐν αἰθέρ' ἐρήμᾳ.

XIV.

Sæpiùs Oceani latet abdita gemma profundis,
 Casso resplendens lumine subter aquas ;
Sæpiùs incultis flos sese expandit in arvis,
 Et vacuos colles implet odore suo.

XIV.

Wie manche Rof' im Thal' erröthet ungefehn,
Haucht ihren Duft umfonft, und ftirbt, vergebens fchön ;
Wie manchen edlen Stein hält vor der Menfchen Sorgen
Der unerforfchte Grund des Oceans verborgen !

XIV.

Chiare vie più che bel raggio sereno
Chiude il mar gemme entro a' suoi cupi orrori ;
E non veduti fior tingono il seno,
E per solingo ciel spargon gli odori.

XIV.

Mais l'avare océan recéle dans son onde
Des diamans, l'orgueil des mines de Golconde ;
Des plus brillantes fleurs le calice entr'ouvert
Décore un précipice ou parfume un désert.

XIV.

Full many a gem of purest ray serene

 The dark unfathom'd caves of ocean bear;

Full many a flower is born to blush unseen,

 And waste its sweetness on the desert air.

XV.

Ενθάδε κωμάτας τάχα τις 'Αμδηνος ιαύει,
Αγρῶ ἀμυνάμενος τὸ πάλαι ταλαπενθέϊ θυμῷ·
Ενθάδε καὶ Μιλτών τις ἄμωσος, ἀνώνυμος εὔδει,
Η Κρομύηλ, πάτρᾳ δ' ἄρ' ὅγ' οὔ πω πήματα θῆκας.

XV.

Forsitan, inter avos, Hampdeni hic ossa quiescant,
 Qui sæva intrepidâ fregerit acta manû ;
Hic sacer ante alios, Miltonus, ἐπώνυμος, adsit,
 Cromvellus ve, vacans proditione ferâ.

XV.

So schläfet hier vielleicht ein Hampden, deſſen Hand
Dem Dränger ſeines Dorfs ſtets muthvoll widerſtand,
Und mancher Milton, ſtumm vermiſcht mit andern Todten,
Und mancher Cromwell, rein vom Blut der Patrioten.

XV.

Forse un rustico Ambdèno ha qui l' avello,
Che al tiràn de' suoi campi oppose il petto,
Un oscuro Miltono, od un Cromuello,
Non mai del sangue de la Patria infetto.

XV.

Là, peut-être sommeille un Hampden de village,
Qui brava le tyran de son humble héritage ;
Quelque Milton sans gloire ; un Cromwell ignoré,
Qu'un pouvoir criminel n'a pas déshonoré.

XV.

Some village Hampden, that, with dauntless breast,

The little tyrant of his fields withstood;

Some mute, inglorious Milton,—here may rest;

Some Cromwell, guiltless of his country's blood.

XVI.

Εὐστοχίας τᾶς τῶν ἐπέων ἐς κῦδος ἱκέσθαι,
Μηδὲ τρομεῖν πενίαντε καὶ ἄλγεα, πατρίδα γαῖαν
Ὀλβίαν ἀφνειάν τε θέμεν, καὶ ἐν ὄμμασιν ἀστῶν
Ἀ κλέα εἰσοράαν καὶ ἃ μήδεα, τοῖσδεσιν οὐχ αἱ

XVI.

Contigit haud illis plausum captare Senatûs,
 Aut populi, impavido pectore, ferre minas ;
Contigit haud illis largiri dona per urbes,
 Audire aut coram — " Rexque Paterque Meus !"

XVI.

Sie konnten nicht, voll Muth, Gefahr und Tod verschmähn,
Nicht, folgsam ihrem Wink', Senate zittern sehn,
Mit Ueberflusse nicht ein selig Land beglücken,
Nicht lesen ihren Werth in eines Volkes Blicken.

XVI.

Tener grave senato intento e fiso,
Di duolo e danni non temer minaccia,
Sparger su' regni con la copia il riso,
E la sua vita altrui leggere in faccia,

XVI.

S'ils n'ont pas des destins affronté la menace,
Fait tonner au sénat leur éloquente audace,
D'un hameau dévasté relevé les débris,
Et recueilli l'éloge en des yeux attendris,

XVI.

Th' applause of listening senates to command;

 The threats of pain and ruin to despise;

To scatter plenty o'er a smiling land,

 And read their history in a nation's eyes,

XVII.

Μοῖραι ἐπεκλωσαντ'· ἀρεταῖς οὐχ ἵλεαι αὐτῶν
Φυομέναις, μὴ δρᾶν πόχ' ὅμως ἀθέμιστα δίδοισαι·
Εκ φόνω οὐ τιμᾶν, κρατεράν τε τυραννίδα κτᾶσθαι,
Καὶ γένει ἀνθρώπων σπείρειν κακὰ νηλέῖ θυμῷ,

XVII.

Præscripsit fines quamvis virtutibus, esse
 Immunes culpæ sors tamen æqua dedit ;
Dum prohibet patriæ vertendo in viscera dextras,
 Civium et adspergi sceptra cruore vetat.

XVII.

Doch schränkte nicht ihr Loos nur ihre Tugend ein,
Die Laster wurden auch in ihrer Hütte klein.
Sie durften nicht mit Blut die Thronenwege gießen,
Die Thore des Gefühls dem Elend' nicht verschließen,

XVII.

Vietò lor sorte : pur se non concede
Che virtù emerga, fa che 'l vizio langue.
Quindi nessun la via chiuse a mercede,
Empio, nè al trono unqua nuotò pel sangue.

XVII.

Le sort, qui les priva de ces plaisirs sublimes,
Ainsi que les vertus, borna pour eux les crimes :
On n'a point vu l'épée, ivre de sang humain,
Leur frayer jusqu'au trône un horrible chemin ;
Ils n'ont pas étouffé dans leur âme flétrie
Et la pitié qui pleure, et le remords qui crie ;

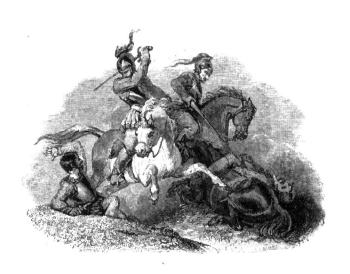

XVII.

Their lot forbad : nor circumscrib'd alone

 Their growing virtues, but their crimes confin'd ;

Forbad to wade through slaughter to a throne,

 And shut the gates of mercy on mankind.

XVIII.

Γνάσιον ἐγκρύπτειν τὸ πάθος καὶ ἀλαθέα γνωμὰν,
Γενναίας τ' αἰδῶς ἐρυθρὸν θάλος αὐτόθ' ἀποσβεῖν,
Ἡ Πλούτῳ τε Τύχας τ' ἐπὶ βωμοῖς ἄνθεα θέσθαι,
Ανθεα Μοισάων στίλβονθ' Ἑλικῶνος ἐέρσαις.

XVIII.

Dum fovet è teneris, generoso pectus honesto,
 Suffundit roseo sive pudore genas;
Virgineum decus aut Musæ temerare recusat,
 Illustrans, casto carmine, Vatis opus.

XVIII.

Nicht Menſchen ſcheu'n, wenn laut im Buſen Wahrheit ſpricht,
Den Zeugen edler Scham nicht tilgen vom Geſicht,
Noch in der Wolluſt Schooß des Weihrauchs ſich erfreuen,
Den zu der Muſen Schmach erkaufte Schmeichler ſtreuen.

XVIII.

Nessun di coscienza il verme rio
Compresse, o spense un candido rossore;
Nè incensi al lusso, e a la superbia offrío,
Arsi a la fiamma de le sacre Suore.

XVIII.

Jamais leur main servile aux coupables puissans
N'a des pudiques sœurs prostitué l'encens;

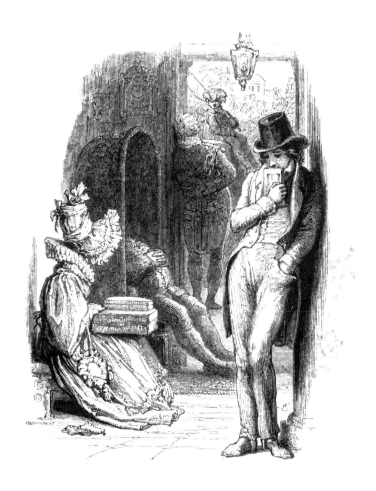

XVIII.

The struggling pangs of conscious truth to hide;

To quench the blushes of ingenuous shame;

Or heap the shrine of Luxury and Pride,

With incense kindled at the Muse's flame.

XIX.

Τῆλ' ἀπὸ τῶν πόλεων, ἐρίδων τ' ἄπο τῆλε διᾶγον,
Οὐδὲ πολυπλανέεσσιν ἐπ' ἐλπίσιν ἐκκρεμάσαν κῆρ·
Εντε βίῳ χθαμαλαῖσι καὶ ἀσφαλέεσσιν ἀτάρποις
Εἷρπον ἄνευ θορύβῳ, καὶ ἐν εὐθυμίᾳ στίβον εὗρον.

XIX.

Hi, procul ex urbis fumo strepituque, volebant,
 Arcentes demens vulgus, inire viam ;
Frigida apud Tempe vitæ, callesque reductos,
 Juverit innocuos excoluisse dies.

XIX.

Von der uneblen Bahn des Städtervolks entfernt,
Hat ihr bescheidner Wunsch Ausschweifung nie gelernt;
Kühl war ihr Lebensthal und dem Geräusch' entlegen;
Zufrieden, wallten sie auf ihren stillen Wegen.

XIX.

Lunge dal popolar tumulto insano
Non mai torsero il piè dal dritto calle,
Seguendo il corso lor tranquillo e piano
Per l'erma de la vita opaca valle.

XIX.

Et leurs modestes jours, ignorés de l'envie,
Coulèrent sans orage au vallon de la vie.

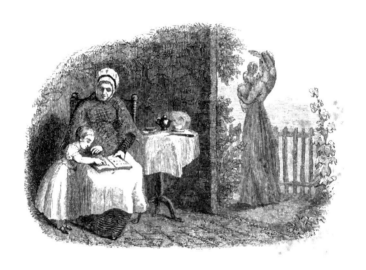

XIX.

Far from the madding crowd's ignoble strife,

Their sober wishes never learn'd to stray;

Along the cool, sequester'd vale of life,

They kept the noiseless tenour of their way.

XX.

Ἀλλ' ἔτι τῆνα καὶ ὀστέ' ἀπ' ἰσχύος ὥστε φυλάξαι
Πλασίον εἰστήκει μναμήια σάθρια πολλὰ,
Καὶ ξόαν' οὐκ ἀσκήθ', ἅ τις οὐκ ἴδρις ἤραρε τέκτων,
Τοῖς ἔγγραπτα μέλη, τὰ καὶ 's δάκρυ ἄγεν ὁδίταν.

XX.

Hæc tamen in justo serventur ut ossa sepulchro,
 Cippus, inæquali culmine, signat humum:
Quà sculpta infabrè, ac incondita carmina nostras
 Exposcunt lacrymas, imaque corda cient.

XX.

Doch ruft ein Denkmal noch, daß die Gebeine schützt,
Zerbrechlich aufgebaut, barbarisch ausgeschnitzt,
Geziert nach altem Brauch', mit ungefeilten Reimen,
Den stummen Wanderer mit Thränen hier zu säumen.

XX.

Pur a difender da villano insulto
Quest' ossa, eretto alcun sasso vicino,
D' incolte rime, e rozze forme sculto,
Qualche sospir richiede al peregrino.

XX.

Quelques rimes sans art, d'incultes ornemens,
Recommandent aux yeux ces obscurs monumens:

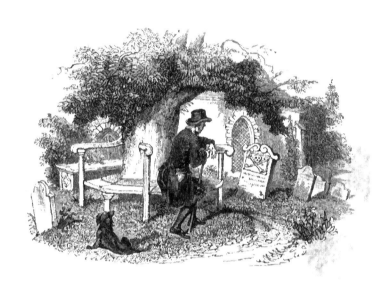

XX.

Yet e'en these bones from insult to protect,

 Some frail memorial still erected nigh,

With uncouth rhymes and shapeless sculpture deck'd,

 Implores the passing tribute of a sigh.

XXI.

Ὠνόματ', ἠδ' ἐτέ' ἐνθὰ, τὰ γὰρ μόνα λείψανα τήνων,
Αντ' ἐλέγων φάμασθ' ἀ Μῶσα 'μωσος ἔθηκεν·
Εντὶ λόγοι τηνεὶ, καὶ ἔπη θελκτήρια παντᾷ,
Ταῦτ' ἐμάθ' ἀγρονομεὺς, θάνατον καὶ ῥάδιον εὗρεν.

XXI.

Scilicet, antiquâ pro laude, elegisque superbis,
 Nomina et ætatem Musa pedestris habet;
Verba Dei passim inscribens, atque " aurea dicta,"
 Rurigena ut discat deniquè pace mori.

XXI.

Die Muse hat sich Lob und Elegie erspart,
Nur ihre Namen und ihr Alter aufbewahrt,
Und den noch leeren Raum mit manchem Spruch' geehret,
Der dieses arme Volk die Kunst zu sterben lehret;

XXI.

I nomi e gli anni, senza studio ed arte,
Di carmi in vece, indôtta man vi segna,
E con sacre sentenze intorno sparte,
Al buon cultore di morire insegna.

XXI.

Une pierre attestant le nom, le sexe et l'âge,
Une informe élégie, où le rustique sage
Par des textes sacrés nous enseigne à mourir,
Implorent du passant le tribut d'un soupir.

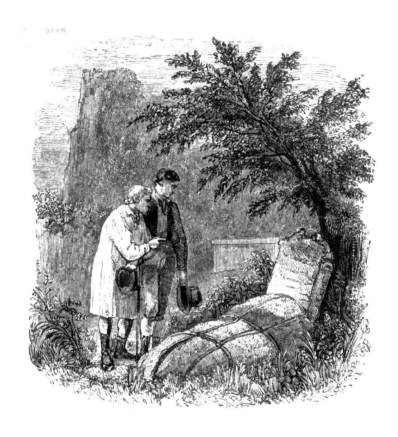

XXI.

Their name, their years, spelt by th' unletter'd Muse,

The place of fame and elegy supply;

And many a holy text around she strews,

That teach the rustic moralist to die.

XXII.

Τίς γὰρ λαθεδόνι στυγερᾷ τόσον εἴχετο θυμὸν,
Ὡς καὶ ἄνευ κλαυθμοῖο βίον γλυκιπενθέα λείπειν;
Τίς καὶ ἀκηδέστως ἐλίπεν σέλας ἁλίω, οὐδὲ
Ἀδὺ τὸ φῶς ἐπόθησε, καὶ ὄμματα τρέψεν ὄπισθα;

XXII.

Nam quis, Lethæi sopitus frigore rivi,
 Corporeæ cuperet solvere fila lyræ?
Longiùs aut vertens tenebrosa ad Tartara cymbam
 Ne bis respiceret littora nota diu?

XXII.

Denn welcher Sterbliche wirft sehnend nicht den Blick
In eine schöne Flur, die er verließ, zurück?
Wer hat gedankenlos, von Sicherheit berauschet,
Dies englisch süße Sein mit jener Nacht vertauschet?

XXII.

Chi mai, chi de l' oblío nel fosco velo
Quest' affannosa amabil vita avvolse,
E lasciò le contrade alme del cielo,
Nè un sospiroso sguardo indietro volse?

XXII.

Et quelle âme intrépide, en quittant le rivage,
Peut au muet oubli résigner son courage?
Quel œil, apercevant le ténébreux séjour,
Ne jette un long regard vers l'enceinte du jour?

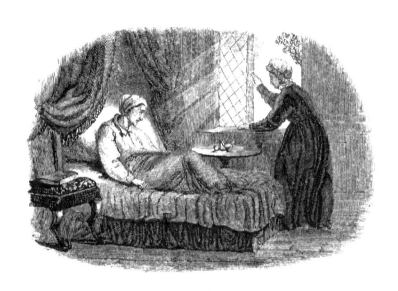

XXII.

For who, to dumb Forgetfulness a prey,

 This pleasing, anxious being e'er resign'd;

Left the warm precincts of the cheerful day,

 Nor 'cast one longing, lingering look behind?

XXIII.

Κέκλιτ' ἀποιχομένα φιλίῳ τιν' ἐφ' ἤτορι ψυχα,
Οὔτις ἀδακρυτὶ φίλῳ ἀνέρος ὄσσε κάλυψεν·
Γᾶς ὑπένερθε φύσις τὰν φωνὰν ἦκεν ἀραιὰν,
Κ' ἄμμιν ὑποσποδίοις τὸ πρὶν πῦρ ἐνδοῖ ἐναίθει.

XXIII.

Pectore dilecto forsan suffulta recumbit
 Ægra anima, atque alas, jam tremebunda, movet ;
Adsint et lacrymæ, " nostri pars optima sensûs,"
 Dum sacro cineres excitat igne Deus.

XXIII.

Ein Auge, das sich schließt, ein halbgebrochnes Herz
Heischt eine Thräne doch und eines Freundes Schmerz ;
Es rufet noch Natur aus unsrer Gruft ; es lodert
Ihr Feuer unverlöscht, wenn unsre Asche modert.

XXIII.

Posa, spirando, in grembo amico e fido
L'alma, e chiede di pianto alcuna stilla.
Da la tomba anco alza Natura il grido,
E sotto il cener freddo amor sfavilla.

XXIII.

Nature, chez les morts ta voix se fait entendre ;
Ta flamme dans la tombe anime notre cendre ;
Aux portes du néant respirant l'avenir,
Nous voulons nous survivre en un doux souvenir.

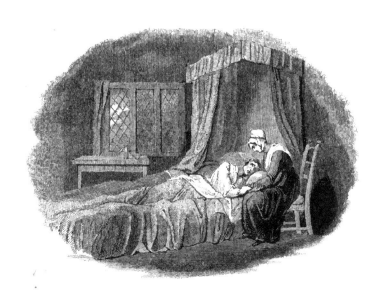

On some fond breast the parting soul relies;

 Some pious drops the closing eye requires;

E'en from the tomb the voice of Nature cries;

 E'en in our ashes live their wonted fires.

XXIV.

Τοί δ᾽ ἄρα, τῶν φθιμένων μεμναμένῳ ἀμφὶς ἀκλαύστων,
Ἀγροτέρων μέλποντι φάτιν σὺν ἀεικέϊ μώσα,
Ἀμφί τοι, αἴ ποκ᾽ ἄρ᾽ ὧδε τεὸν πότμον ἐξερεείνῃ
Οἰοπόλος τις ἰών, μελεδήμασι θυμὸν ἰανθείς,

XXIV.

Tu tamèn, in nostris te versans sedibus, hospes,
 Qui vici exequias solvis ab ore pio,
Et tu rite pari, forsan, celebrabere famâ,
 Nec tibi, quem dederis, optime! deerit honos.

XXIV.

Du, der die Todten hier, die keine Zunge preiſt,
Aus der Vergeſſenheit durch deine Leier reißt,
Vielleicht ſucht, traurend, einſt ein dir verwandtes Weſen
Noch deinen Hügel auf und fragt, wer du geweſen.

XXIV.

Ma se di te, che in semplice favella
Narri storia di gente oscura, umìle,
Fia che brami saper qualche novella
Quà giunto a sorte spirto ermo e gentile ;

XXIV.

Et toi, qui pour venger la probité sans gloire,
Du pauvre dans tes vers chantas la simple histoire,
Si, visitant ces lieux, domaine de la mort,
Un cœur parent du tien veut apprendre ton sort,

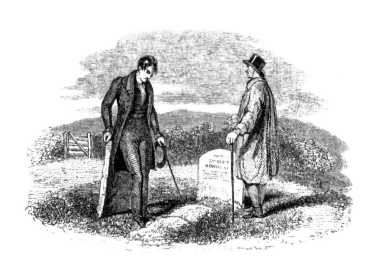

XXIV.

For thee, who, mindful of th' unhonour'd dead,

 Dost in these lines their artless tale relate;

If 'chance, by lonely Contemplation led,

 Some kindred spirit shall inquire thy fate;

Ὡς τάχα τὰν πολιὰν γεραρὸς τρίχα βωκόλος εἴποι,
" Τῆνον ὑπ' ἠοῖοι πάλι πολλάκις εἴδομες ἄλλες,
Ερσαν ἀποψήχων ταχινοῖς ποσὶ ποσσάκις εἶρπε,
Αλίω ἀντιόων ἀνά τ' ἄγκεα, καὶ νάπος αἰπύ.

XXV.

" Illum mane novo (quærenti Rusticus aiat,
 Cui nive conspersit tarda senecta comas)
Vidimus usquè citis properantem passibus, ortum
 Solis ut adspiceret graminis inter opes.

XXV.

Da ſpricht ein grauer Hirt: "wann dämmernd auf den Höhn
Der Morgen zitterte, hab' ich ihn oft geſehn;
Durch das bethaute Gras rauſcht' er mit ſchnellen Füßen
Zu jenem Hügel hin, die Sonne zu begrüßen.

XXV.

" Spesso (forse dirà Pastor canuto)
La rugiada crollar giù da l' erbetta,
Frettoloso in su l' alba i' l' ho veduto,
Per incontrare il Sol su l' alta vetta.

XXV.

Sans doute un villageois, à la tête blanchie,
Lui dira : " Traversant la plaine rafraîchie,
Souvent sur la colline il devançait le jour :

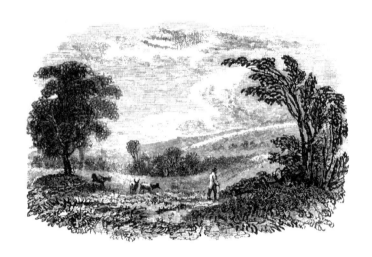

XXV.

Haply, some hoary-headed swain may say:

"Oft have we seen him, at the peep of dawn,

Brushing, with hasty steps, the dews away,

To meet the Sun upon the upland lawn.

XXVI.

" Ενθάδε τῶς ἁ φαγὸς ἐὔσκια φύλλα πετάσδει,
Λ ῥίζας γάιαθε πεπλεγμένας ὕψι δονεῦσα,
Γώνατα κεκμακὼς τὸ μεσαμβρινὸν ἄσυχα κεῖτο,
Νάμαθ' ὑπὲρ ποταμῶ, τὰ πέλας κελάρυσδε, τανυσθείς.

XXVI.

" Illic quà patulo viret ista cacumine fagus,
 Tortilis implicitans, altior, orbe pedes,
Solibus æstivis, et molli stratus in herbâ,
 Spectabat cursum prætereuntis aquæ.

XXVI.

" Dort an der Buche Fuß, die schon vor Alter nickt,
Die Wurzeln aufwärts trägt und ihre Zweige bückt,
Streckt' er am Mittag sich verdrossen, unbelauschet ;
Starr sah er in den Bach, der dort vorüber rauschet ;

XXVI.

" Sotto quell' ondeggiante antico faggio,
Che radici ha bizzarre e sì profonde,
Prosteso e lento, al più cocente raggio,
Fiso ascoltava il mormorar de l' onde.

XXVI.

" Quand au sommet des cieux le midi de retour
Dévorait les coteaux de sa brûlante haleine,
Seul, et goûtant le frais à l'ombre d'un vieux chêne,
Couché nonchalamment, les yeux fixés sur l'eau,
Il aimait à rêver au doux bruit du ruisseau :

XXVI.

" There, at the foot of yonder nodding beech,

That wreathes its old fantastic roots so high,

His listless length, at noontide, would he stretch,

And pore upon the brook that babbles by.

XXVII.

" Ἄλλοκα τῆνο κατ' ἄλσος ἀλώμενος, ὥς τι σεσαρὸς
Μειδιόων τις ἔβα, φρένας ἠλός, χείλεσι μύσδων·
Ἄλλοκα λυγρὸν ὁρῶν, καὶ ἐπὶ χθονός ὄμματα πήξας,
Ὣς δύσερώς τις ἄγαν καὶ ἀμήχανος ἀμφεπολεῖτο.

XXVII.

" Sylva ubi fert virides, velut in ludibria, ramos,
 Nescio quid meditans, sæpe terebat iter ;
Tristis, inaccessus, nunc secum solus oberrans
 Lymphatus curis, victus amore gravi.

XXVII.

" Balb ſchlich er in den Hain, und ſchmerzlich lächelt' er ;
Balb murmelt' er vor ſich verworren Träume her ;
Balb hing er, bleich, ſein Haupt, wie ein Verlaſſ'ner, trübe,
Genagt von innerm Gram' und hoffnungsloſer Liebe.

XXVII.

" Ora ridente di scherzevol riso
Movea presso quel bosco il passo errante,
Mormorando sue fole, or mesto in viso,
O pien di cure, o disperato amante.

XXVII.

" Le soir, dans la forêt, loin des routes tracées,
Il égarait ses pas et ses tristes pensées ;
Quelquefois, en quittant ces bois religieux,
Des pleurs mal essuyés mouillaient encor ses yeux.

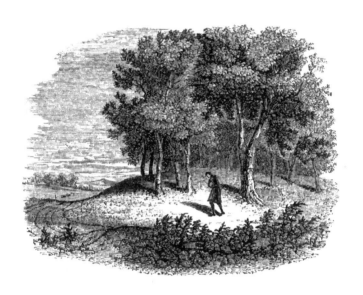

XXVII.

" Hard by yon wood, now smiling, as in scorn,

 Muttering his wayward fancies, he would rove;

Now drooping, woeful, wan, like one forlorn,

 Or craz'd with care, or cross'd in hopeless love.

XXVIII.

" Ἀλλὰ τὸν οὐκ ἴδον αὖτις, ἐφ' ἁλίω ἀντέλλοντος
Οὐκέτι κεκλιμένον ποτὶ δένδρεον, οὐ παρα παγὰν·
Δεύτερον ἆμαρ ἔπηνθεν, ὅδ' οὐκέτι πᾷ πόκ' ἀν' ὕλαν,
Οὐκέτ' ἀνὰ δρυμὼς, καὶ Νυμφᾶν ἱερὸν ὕδωρ.

XXVIII.

" Matutino autem scandenti tempore collem
 Nuper ab his casulis abfuit ille mihi ;
Nuperior frustrà quæsivi in sede quietâ,
 Nec circa saltus, nec prope flumen erat.

XXVIII.

" An einem Morgenroth' eilt' ich zum Hügel hin,
 Wo ich ihn immer fand und — da vermißt' ich ihn.
Ich eilte nach der Au zu seinem Lieblingsbaume,
Allein ich fand ihn nicht, wie sonst, in süßem Traume.
Ein zweiter Morgen kam ; weit schaut' ich um mich her,
Doch ich erblickt' ihn nicht am Bach', im Hain' nicht mehr.

XXVIII.

" Una mattina in su l' usato monte
Io più nol vidi al caro arbore appresso :
Venne poi l' altra, e pur in quella al fonte
Non si mostrò, nè al poggio, o al bosco istesso.

XXVIII.

" Un jour, près du ruisseau, sur le mont solitaire,
Sous l'arbre favori, le long de la bruyère,
Je cherchais, mais en vain, la trace de ses pas ;
Je vins le jour suivant, je ne le trouvai pas :

XXVIII.

" One morn, I miss'd him on the 'custom'd hill,

 Along the heath, and near his favourite tree;

Another came,—nor yet beside the rill,

 Nor up the lawn, nor at the wood, was he;

XXIX.

" Ἥματι δὲ τριτάτῳ σὺν δάκρυσιν, ᾠμωγαῖς τε
Εκφέρετ', ἀμφὶ δέ μιν κλαῦσαν νέοι ὧδε ταφέντα·
Αλλ' ἄγε ταῦτα, δύνῃ γὰρ, ἀνέγνως γράμματα φράσδευ,
Ενθετα τῷδε λίθῳ, τὸν ἐπεσκίας' ἄκρον ἄκανθα."

XXIX.

" Tertia lux oritur, sonus exauditur amari
 Planctûs; effertur corpus, amatque rogum;
Haud mora, sacratas quà semita ducit ad ædes,
 Multa gemens, longo funere, turba venit.

XXIX.

" Tags d'rauf, ach, fahn wir ihn bei Liedern und bei Klagen
In feierlichem Zug' nach' unserm Kirchhof' tragen.
Siehst du den Dornstrauch dort? Komm — lesen kannst du ja —
Lies, hier an diesem Stein' steht seine Grabschrift. Da!"

XXIX.

" La terza al fin con lenta pompa e tetra
Portar si vide al tempio : or t' avvicina,
E leggi tu, che 'l sai, scolpito in pietra
Lo scritto, sotto quell' antica spina."

XXIX.

" Le lendemain, vers l'heure où naissent les ténèbres,
J'aperçus un cercueil et des flambeaux funèbres;
A pas lents vers l'église on portait ses débris :
Sa tombe est près de nous ; regarde, approche, et lis."

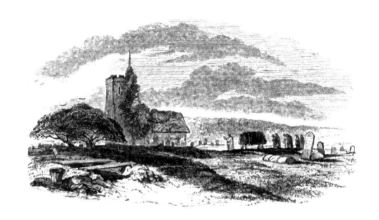

XXIX.

" The next, with dirges due, in sad array,

 Slow through the church-way path we saw him borne.

Approach and read (for thou canst read) the lay,

 Grav'd on the stone beneath yon aged thorn."

XXX.

Ενθάδ᾽ ὑποχθόνιος κεῖται Νέος, ᾧ τόδε σᾶμα,
 Τόν ζώοντ᾽ ἀτυχὴς ἔσχεν ᾿Ανωνυμία·
Οὐκ ἐξ εὐγενέων μὲν ἔην, φίλος ἀλλ᾽ ὅγε Μώσαις,
 Μναμοσύνα τὸν ἰδὼν, παῖς ἐμὸς ἔσσετ᾽, ἔφα.

XXX.

" In lapide incisum stat carmen, 'nominis umbra,'
 Quà trudit flores oxyacantha suos ;
Perlege quod scriptum est, accedens, advena ! bustum,
 Perlege, nam nobis doctus es alta loqui."

XXX.

Ein Jüngling ruhet hier in unsrer Mutter Schooß',
Dem Glücke nicht bekannt, durch keinen Nachruhm groß.
Sein niedrig Wiegenbett verschmähten nicht die Musen,
Und Schwermuth weihte sich zur Wohnung seinen Busen.

XXX.

Giovane a fama ignoto et a fortuna
 Quì vien che in grembo de la terra dorma.
Sofía non isdegnò sua bassa cuna,
 E tristezza il segnò de la sua forma.

XXX.

Sous ce froid monument sont les jeunes reliques
 D'un homme, à la fortune, à la gloire inconnu :
La tristesse voilait ses traits mélancholiques ;
 Il eut peu de savoir, mais un cœur ingénu.

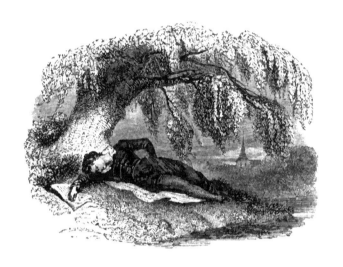

Here rests his head upon the lap of Earth,

 A youth, to fortune and to fame unknown ;

Fair Science frown'd not on his humble birth,

 And Melancholy mark'd him for her own.

XXXI.

"Ηπιος ἦν, καὶ πολλ' ἐχαρίσσατ' εὔφρονι θυμῷ,
　　Εσπετ' ἀμοιβαία χ' ἅ χάρις ἐκ Θεόφιν·
Δάκρυα δυστήνοισι, τί γὰρ πλέον ἔσχεν; ἔδωκεν,
　　Τὸν φίλον οἱ, πλέον οὐκ ἤθελ', ἔδωκε Θεὸς.

XXXI.

Hìc caput adponit gremio telluris ephebus,
　　Cui nunquàm est opibus lætior orta dies;
Sed placido adspexit nascentem lumine Musa.
　　Et mens plena fuit Relligione loci.

XXXI.

Voll Güte war sein Herz und der Verstellung feind;
Voll Güte krönete der Himmel sein Begehren.
Er schenkte Leidenden sein ganz Vermögen — Zähren;
Gewährt ward ihm dafür sein ganzer Wunsch — ein Freund.

XXXI.

Sincero era il suo cuore, e di pietate
　　(E dal ciel n' ebbe ampia mercede) ardea.
Un sospir, quanto avea, diè a povertate,
　　E un amico impetrò, quanto chiedea.

XXXI.

Les pauvres ont béni sa pieuse jeunesse
　　Dont la bonté du ciel a daigné prendre soin;
Il sut donner des pleurs, son unique richesse;
　　Il obtint un ami, son unique besoin.

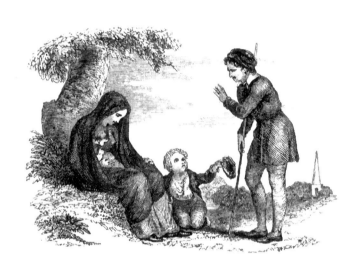

XXXI.

Large was his bounty, and his soul sincere ;

 Heaven did a recompense as largely send :

He gave to Misery all he had — a tear ;

 He gain'd from Heaven ('twas all he wish'd) a friend.

XXXII.

Ἀλλὰ τύγ', οἷος ἂν ᾖς, κακὸς ἦ ὅγ' ἄρ' ἐσθλὸς, ἐρευνῶν
Παῦσαι, ποττὸ φάος μὴ τύγ' ὅσ' ἄλιτ' ἄγων·
Ἐσθλὰ γὰρ οἱ κακά τε τρομερῇσι σὺν ἐλπίσι κεῖται
Ἐν κόλποις ὑπάτω τῶ Πατρὸς, ἠδὲ Θεῶ.

XXXII.

Candidus, et simplex, miseris succurrere promptus,
 E cælo accepit dona repensa tamen;
Quod potuit, flebat sempèr cum flentibus ipse,
 Quod cupiit, trepido semper amicus erat.

Ne scrutare ultrà — quodcunque peregerit olim
 Restat, et à nobis facta tacenda manent;
Crede igitur Superis; trutinâ ponentur in æquâ,
 Quum steterit cunctis Ultimus Iste Dies.

XXXII.

Wag' in das Heiligthum nicht tiefer einzuschauen,
Das seine Tugenden und seine Fehler mißt.
Ach, Beide liegen sie mit zitterndem Vertrauen
In dessen Brust versenkt, der Gott und Vater ist.

XXXII.

Più oltre non cercar, nè d' ir scoprendo
 Ti studia le sue buone, o le triste opre.
Fra la speme e 'l timor, nel sen tremendo
 Di Dio si stanno, e denso vel le cuopre.

XXXII.

Ne mets point ses vertus, ses défauts en balance;
 Homme, tu n'es plus juge en ce funèbre lieu;
Dans un espoir tremblant il repose en silence,
 Entre les bras d'un père et sous la loi d'un Dieu.

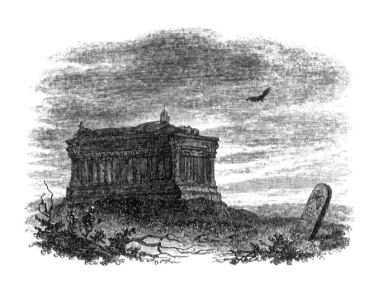

XXXII.

No further seek his merits to disclose,

Or draw his frailties from their dread abode :

(There they alike in trembling hope repose,)

The bosom of his Father and his God.

Milton Keynes UK
Ingram Content Group UK Ltd.
UKHW050229230324
440007UK00005B/88